Over and Over, Again and Again

Contents

Over and Over, Again and Again 2004 detail

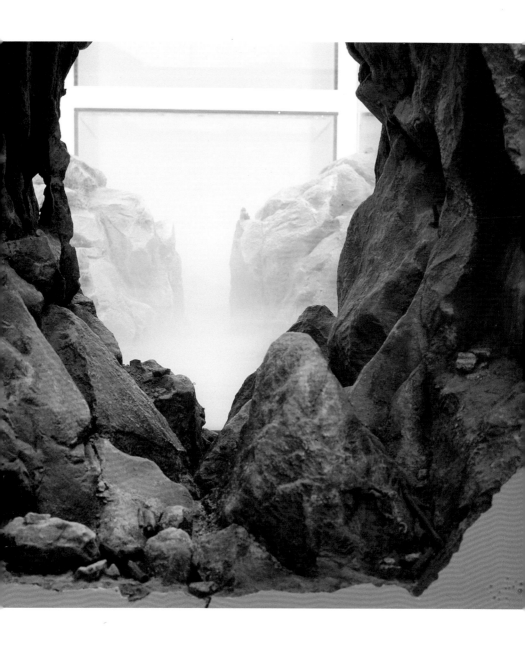

Introduction

Susan Daniel-McElroy

DIRECTOR, TATE ST IVES

The impulse to create secret worlds comes to us when we begin to realise the depth of our imagination and the potential in us to always be elsewhere. When, as children, we daydreamed of secret kingdoms – caves in which a sleeping king and queen awaited our discovery and where we could finally become a fairy princess – we eluded the humdrum cycles of our daily caution and duties. Transported by our daydreams, absorbed and elevated by joy or terror, we played on in unseen dimensions (unseen by grown-ups, that is), where our desire held sway above all others.

The fabricated worlds presented by Mariele Neudecker with their careful construction and simulated weather, seem to encapsulate the atmosphere and promise of the sublime imaginary moment in our memory. The landscapes created for her tank works, although not large, are representations and reproductions of the Romantic landscape by such iconic artists as Caspar David Friedrich, whose paintings allowed us to look down and across sublime vistas. Her tank pieces envelope our gaze, prickle our imagination and lure us in to see beyond the obvious – albeit enchanted – illusion, we know that this is no representation of reality. But our imagination is caught, we look beyond the pleasure principle, to see what is behind the illusion and whilst Neudecker takes us into the light, she also reminds us of the creepy, spine-chilling quality of the silent forest in a continuing and clever critique of its cultural exploitation.

Gaston Bachelard explains this process beautifully in *The Poetics of Space* pp183–184 (Orion Press, New York 1964):

One might say that immensity is a philosophical category of daydream. Daydream undoubtedly feeds on all kinds of sights, but through a sort of natural inclination, it contemplates grandeur. And this contemplation produces an attitude that is so special, an inner state that is so unlike any other, that the daydream transports the dreamer outside the immediate world to a world that bears the mark of infinity. ...In analyzing images of immensity, we should realize within ourselves the pure being of pure imagination. It then becomes clear that works of art are the *by-products* of this existentialism of the imagining being. In this direction of daydreams of immensity, the real *product* is consciousness of enlargement. We feel that we have been promoted to the dignity of the admiring being.

Immensity is within ourselves, it is attached to a sort of expansion of being that life curbs and caution arrests, but which starts again when we are alone. As soon as we become motionless, we are elsewhere; we are dreaming in a world that is immense.

David Blayney Brown's thoughtful text gives us new insights into the range of Neudecker's work and encourages us to discover more. We are singularly grateful to our Tate colleague for his participation in this project. In bringing an exhibition and publication together, there are many Tate colleagues too numerous to thank here individually, but their expertise is vital to the delivery of our project. Our warm thanks to the musical composer Douglas Young whose text offers a musician and film-maker's insights into Neudecker's film *Winterreise.* Barbara Thumm – her gallerist – has been instrumental in realising the exhibition for St Ives and we are thankful for her support in the creation of new works in this exhibition.

Finally, we are exceptionally pleased and grateful for the artist's commitment in making this small but perfect exhibition.

Mariele Neudecker: More Tracks in the Snow

David Blayney Brown

I had not been prepared for the polar bears. Prowling, rearing or clawing the air in their glass cases, there they were, almost if not all the bears that could be found in Britain, white creatures in a white hall in the centre of Bristol's art space at Spike Island – awaiting a forthcoming installation. But as Neudecker's own vitrines were in the next room, accessible only this way, it was impossible to ignore these presences from the icy North. Impossible, too, to ignore the fact that outside it was snowing. Wherever you go, it snows, someone said. We looked at Neudecker's film *Winterreise* (2003) – more snow, leaden skies, frozen seas. Part of the film is set in Helsinki, where I was to be the next evening. Two days later, I was looking at some of the very same things – the great Silja Line ferries carving their way through the snow-covered ice, leaving their tracks behind them, soon to close again; the fir trees, also heavy with snow; the island of Suomenlinna. You must go to the island, she said; there are fine things to see. Through more snow appeared the strata of its changing history; an exquisite Neo-classical monument to king Gustave III from its Swedish period, barracks erected by the Russians after they took it in 1808, a Nazi U-boat base.

All good things to see through Neudecker's eyes. To make one think how lives and experience converge or clash, as if there are maps on which paths are predestined to cross, suddenly creating a narrative. About the vitrine, its confinement and containment, scale and distortion; about capturing or modelling the natural world. About the weather and time. I doubt this would surprise Neudecker. She is fascinated by maps, and uses them often. She has said that living in Budapest, when the street names were changing along with the regime, developed this. No doubt it enhanced her sense of their fluidity and contingency. Presented as rational or definitive images of the globe, they are anything but; their boundaries and names are artificial

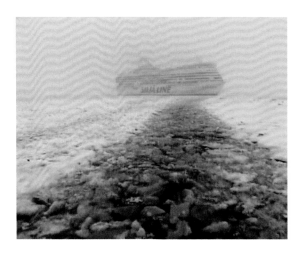

Winterreise 2003
Der Leierman (The Hurdy Gurdy Man)
Film still
Commissioned by the Contemporary Art Society Special Collection Scheme
on behalf of Leeds City Art Gallery with Funds from the Arts Council Lottery, 2003
(in collaboration with Opera North)

and changing creations, our response to them is modified by memory, culture, language, imagination too, and changes to the earth's surface and climate mean that no map can be for ever. Hers are moulded into contours, which they may or may not actually describe. Or she has created new ones, excavating the contours of the English Channel – and glimpses of life in England and France – from a photo album found in a thrift shop, or making a parallel universe from maps drawn from memory.

Neudecker's maps are not just for looking. They suggest the journeys which concentrate and distil experience – or let imagination soar. In some significant works using latitude and longitude, she reminds us of the relativity of time and space, and balances the roles of memory and the subconscious along with empirical calculation. Her early plaster casts of the meridian line at Greenwich, *Meridian Installation* (1990), and later *The World's Prime*

Meridian (0100H–2400H) (1997) remind us that, as Maite Lorés has written, 'longitude equals time and that time is geographically relative. Latitude, on the other hand, is empirically bound to the physical universe. Its deviations north and south of the Equator are mapped directly onto the astral chart and can therefore be more readily fixed in memory'.[1] Latitude is addressed along with cultural and emotional memory in Neudecker's *Winterreise.* This series of twenty-four short films was made in four locations on the 60th parallel north – Shetland, near Oslo, in Helsinki and St Petersburg in the winter of 2003. Schubert's settings of Müller's poems are beautifully sung in the accompanying soundtrack, the related texts floated over the visuals, while in a separate *Prelude* (2003) to the cycle, they are read by people Neudecker happened to meet on her way. The melancholy, restlessness and loss of the lovelorn narrator's soul is evoked not by any sad beauty in the settings, but by their very banality, which creates a sense of non-arrival, of ongoing movement – on a descending escalator or those big, passing ferries. The traveller's journey is infinite, hardly broken by inconsequential pauses. Longitude and latitude are the determinant of *Another Day* (2000), a simultaneous record of the rising and setting sun at opposite ends of the globe, at Ponta Negra in the Azores and Wilson's Promontory, Australia's southernmost lighthouse. Because of its more obvious beauty and larger scale, and because of enduring associations of dawn and nightfall with beginnings and endings, one comes to this with different expectations, a desire to invest it with significant meaning. It is disappointing, for example, to realise that this is not the first sunrise of the new millennium, that in fact it was filmed five months later. Above all, one wants to relate it to Romantic depictions of sky and weather, to their sense of the transcendental and the Sublime.

Kant famously ruled that 'it is the disposition of soul evoked by a particular representation engaging the attention of the reflective judgement, and not the Object, that is to be called sublime'.[2] Neudecker's representations are pitched precisely at that disposition, conscious that it also now involves nostalgia. What interests her most in Caspar David Friedrich's *The Cross in the*

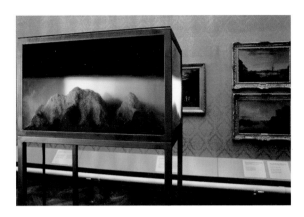

Stolen Sunsets 1996
Glass, water, food dye, salt, fibre glass
45 x 65 x 180 cm
Arts Council Collection
Installation *Private View*, Bowes Museum, Barnard Castle, 1996
Photograph J Hardman-Jones

Mountains (1808), she says, is that this is not an altarpiece depicting the
Crucifixion itself, but a landscape with a wooden roadside cross. It is
knowingly deceptive. Yet, from the time of its first showing in the artist's
Dresden studio, placed between candles on a cloth-hung table, it has invited
multiple readings and became known – after its first home – as the
'Tetschen Altar'. Its own sun is setting because the real God no longer
shows himself on earth – just the sort of symbolism we are hard-wired to
expect in such effects, especially when painted by this artist. His, Neudecker
says, is an art of symbol and metaphor; it is not really painting – and she
trained as a painter. For this, and for his own radical play with ways of seeing
and representation, Neudecker would surely have come to Friedrich even
had he not been so firmly and contentiously marked on the German cultural
map. In her tank piece *Stolen Sunsets* (1996), she referred to a remark by
Hans-Jürgen Syperburg in a 1977 film – 'Hitler stole our sunsets'. And much
more besides, of course, including Friedrich who was presented by Nazi

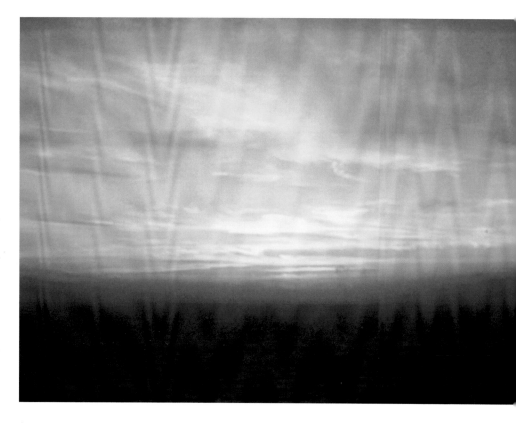

Another Day
(simultaneous record of the sun rising and
setting in two opposite locations on the globe
– South East Australia and West Azores) 2000
Two film stills in lightboxes
79 x 104 x 20 cm each
Courtesy the artist, Galerie Barbara Thumm
Photograph David Brandt

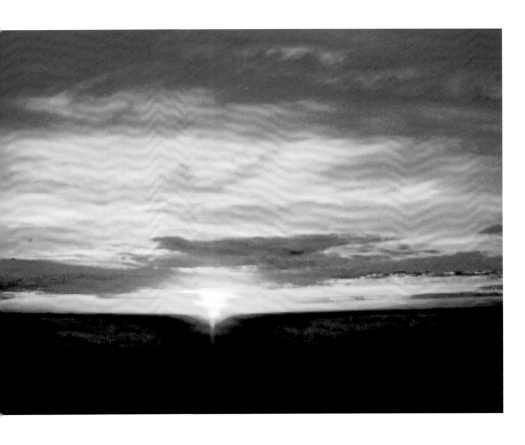

propagandists as the ideal artist and the archetype of German Romantic landscape. Whether he was still in need of reclamation from this perversion of history by the time she began to explore his art, as some have claimed, must be questionable. Nevertheless it has been a rich vein in her work, a particular project within the larger project of her tank series, much as Friedrich has been taken to contain or epitomise Romanticism itself.

It was the installation of *Stolen Sunsets* in a gallery at the Bowes Museum at Barnard Castle that led Neudecker to the idea of replicating other artists' work, and then especially Friedrich's, in glass tanks, constructing models of their images and surrounding or rooting them in the chemical miasma which, like some medieval alchemist, she mixes to mimic mist or rain. The uneasy relationship between the solid and nebulous, the distorting or multiplying effects of the tanks when seen from different angles and the intriguing but also unnerving experience of being able to walk round things familiar only on a flat surface (as if we could go behind the artist's eye and enter his mind) add up to a suggestive play on the dialectics of Romanticism itself – in which objectivity and rationalism yields to intuition, the known to the felt. As so often in her work, Neudecker plays with illusion; but as she has said, she wants the illusion to fail. While her tanks, at first glance, objectify old pictorial friends, they soon make them more mysterious and unknown. This is rewarding with Friedrich, who played so remarkably with pictorial space, taking us with him to look down on the peaks of misty mountains or to peer over the edge of precipitous cliffs, and always painted, as he said, with his mind's eye. The glass wall of the tank intervenes between object and viewer much as Friedrich inserts his signature figure looking into the landscape, the image of the artist himself whose interpretations we are invited to share. Friedrich's various views of his Dresden studio window, only partly opened to the world outside to emphasise the interior nature of his vision, have been memorably reworked by Neudecker in *Who Has Turned Us Around Like This?* (2002) – perhaps a farewell or a summing up of her study of the artist; in a tank of two halves, the window separates the studio space, scrupulously

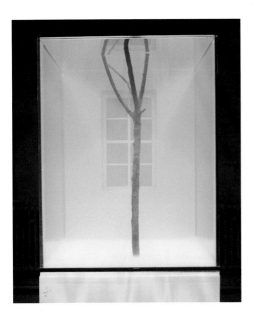

Who Has Turned Us Around Like This? 2002
Glass, water, acrylic medium, salt, fibre glass, plastic
50 x 125 x 170 cm (including plinth)
Collection of the artist, Galerie Barbara Thumm
Photograph Woodley and Quick

modelled on Friedrich's own, from a different exterior in which a tree is shrouded in fog. With their small, sometimes miniature scale, the tanks invite us to look down into their subjects as well as walk around them, much as Friedrich's own viewpoints sometimes hover somewhere above ground level, thus eliminating the conventional landscape foreground.

Novalis's aphorism that Romanticism made the strange familiar and the familiar strange would certainly apply to Neudecker's tanks. Far from freezing and containing the works that inspire them, they release them into new life. They are not and cannot be literal. The quotational tank in this exhibition, *There Go I* (2004), is a part-recreation of Arnold Böcklin's *Island of the Dead* (1880). She has

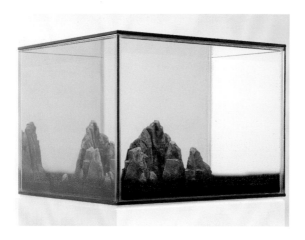

There Go I 2004
Glass, water, food dye, salt, fibre glass
44 x 57 x 63 cm plus plinth
Courtesy the artist, Galerie Barbara Thumm
Photograph Woodley and Quick

been compelled to reinvent the sinister island in the round, to imagine its other side. Its pointy rocks and trees rise from a sea of deepest blue-black. Neudecker has left out the boat bearing its passengers to the island. But look carefully, both on the side of the island borrowed from the picture and on the other, and there are two tiny landing stages, awaiting its arrival. She wanted to make something that was 'cold and deep', that evoked the North, that was 'deadly – not warm or paradisical'. Hers is certainly not the Romanticism of the South, that longs, with Goethe, for the lands of the lemon tree. But it is not without humour at least. Once again here, she has followed an artist's lead on a voyage into the subconscious; it is helpful to have a choice of two landing places.

In other tanks, Neudecker has broken away from quoting other artists to confront the landscape imagery that inspired them. In doing so, she has released it from their own highly selective vision, or continued her critique of their subsequent cultural exploitation. *It is a Good Thing to Lose Control*

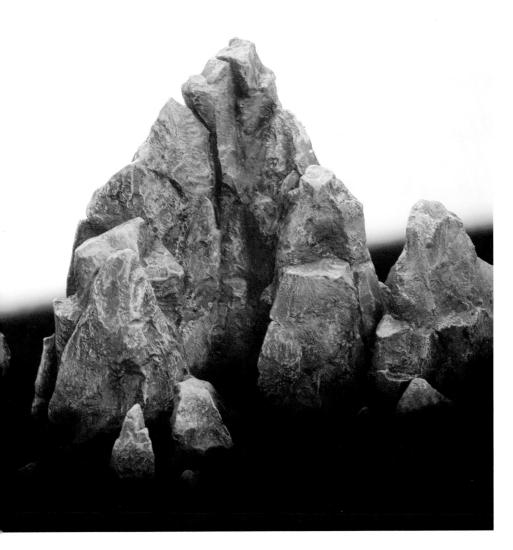

ere Go I 2004 detail

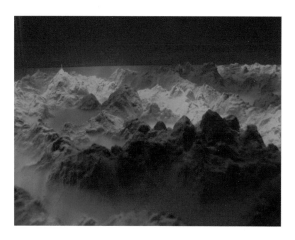

It is a Good Thing to Lose Control Sometimes 2000 detail
Glass, water, acrylic medium, salt, fibre glass, plastic
106 x 124 x 136 cm (including plinth)
Collection Thyssen Foundation, Vienna
Photograph Woodley and Quick

Sometimes (2000) shows her own love of looking down, of the aerial survey, in its almost limitless range of mountains spread out low in their case, while the Romantic disposition to altered states is acknowledged in the title with, perhaps, a hint that such traditions exert their own undue 'control'. The archetypal German forest has been a recurrent theme. At Tate St Ives, it is represented by *Things Can Change in a Day* (1998), its title expressing her preoccupation with time and its mutations. *I Don't Know How I Resisted the Urge to Run* (1998) presents the forest, the trees swimming in mist, as a primeval space or realm of the subconscious. The title hints at the alarms therein and the fears they bring – not least of those who have corrupted such symbols by their evil nationalism. The work is both beautiful and creepy. Even without a name, it would be spine-tingling. Its trees are half-dead, rotting in the damp earth of the forest floor. *Far into the Day* (2000) carries the idea of decay and corruption further. Some crumbling, eroding mountains, dotted with dying trees, are contained within a case that is mounted on a cenotaph-

like plinth. As its grandeur fights with the sadness and disappointment it supports, the piece becomes a memorial – to a dying planet, to landscape art and its practitioners, to the culture that valued such things in their prime. Its polar opposite, perhaps, is the magnificent *Unrecallable Now* (1998) – a glittering, pure mountainscape rising above cloud, liberated from the case and spread across a floor. Here again we look down, but at a world still bright and clean. With its own suggestive title, this, too, shows what we have lost.

Outside her tank series, Neudecker has continued her references and her enquiry into seeing and perception. The Norwegian, Lars Hertewig's encounter with German Romantic art (or rather, artists) had grave repercussions. He was

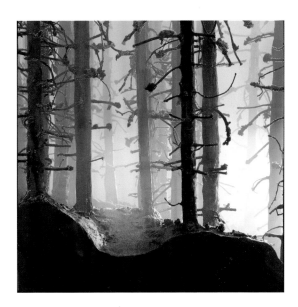

I Don't Know How I Resisted the Urge to Run 1998 detail
Glass, water, acrylic medium, salt, fibre glass, plastic
61 x 75 x 90 cm plus plinth
Collection Johannes and Bernarda Becker, Cologne
Photograph Woodley and Quick

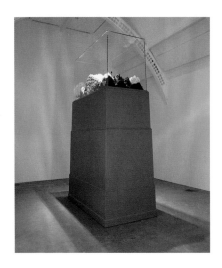

Far Into the Day 2000
Mixed media including wood, acrylic glass and fibre glass
126 x 244 x 410 cm
Collection of the artist, Galerie Barbara Thumm
Photograph Woodley and Quick

inspired to paint his own iconic pictures of his national landscape of fjords and forests, but as a rough 'provincial' from another country he was so tormented by his fellow students at the Düsseldorf academy that he ended mad, living in an asylum and reduced to painting his now imaginary landscapes on cigarette papers with tobacco water, so that they became postcards from an inner hell. Does Neudecker, herself from Düsseldorf, know this? Or is it another of those strange crossings of paths? At any rate, it adds another layer of meaning to her *Deluge* (1998), in which a forest landscape by Hertewig (c.1865) is projected along with Francis Danby's *Deluge* (1840) – an axiomatic Romantic image of the Apocalypse – on video monitors facing each other in a darkened space. The images curve back to form globes or planets, spinning in the dark, advancing and retreating, to a deafening soundtrack of wind and thunder. These are landscapes of the mind, tormenting and tormented. In their constant repetition they suggest a continuum, but also they seem prophetic. Coming it seems from

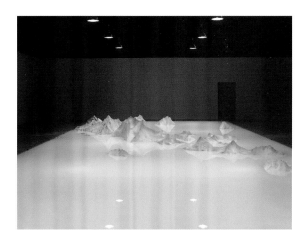

Unrecallable Now 2001
Installation Yokohama International Triennale
Glass and metal tank, water, acrylic medium, fibre glass
120 x 850 x 1950 cm
Collection of the artist, Galerie Barbara Thumm
Photograph Shigeo Anzai

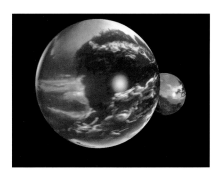 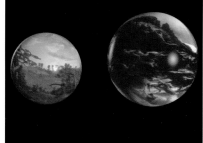

Deluge I and ***Deluge II*** 1998
Video stills
33.6 x 45 cm
[2 videos of digital loop film, made in infini 3D on two
opposite monitors with 5 metres distance]
Collection the Artist, Galerie Barbara Thumm

an irrational place, they may yet come true. If there is a moral, it is that the catastrophic human failure that destroyed Hertewig's vision of nature will justify nature's ultimate revenge.

Here as so often in Neudecker's work, whether in film, video, or in her models and cases with their careful constructions and simulated weather, one is fascinated by technique and process. The cleverness of the concept and its technical achievement fights with the strangeness of its effect. Our own ways of seeing, as well as hers, are brought into question. She makes conscious play with the science of optics. The triptych shown at Tate St Ives, *Over and Over* (2004), *Again and Again*, repeats the same subject of a cave. What would normally be experienced only from within or from its opening is presented in the round, and the reflections and transformations of the image from tank to tank echo those set up by a single case in an extended refrain. The effect is almost musical. The daughter of a chemist, she knows how to mix her mists and clouds, but to us they appear little miracles. The sciences inform her work, and she accesses whatever technologies are needed to translate her ideas. *Another Day* (2000) required highly sophisticated satellite communication between the twin locations and the use of complex British and American sun calculation equipment. Like the Romantic artists she has investigated, she researches other disciplines, following their lead in incorporating the natural sciences or chemistry, whether enlightened and rational, or mystical, into their own sensibility. Unavoidably, her work puts me in mind of Ruthven Todd's remarkable book *Tracks in the Snow* (1946). Dedicated to a British poet and artist, Geoffrey Grigson and John Piper, themselves post-Romantics, this charted the impact of earlier sciences on Romantic artists, and likened the project to drawing a 'dotted and uncertain line across the face of a map, one of these indications of the possible or probable course of a river across a still unexplored or uncharted territory'. The map, he said, was full of 'strange bays and monstrous headlands'.[3]

This takes us back to Neudecker's changeable and fantastic maps, and to her charts of space and time, looking backwards and forwards, up or down. She is

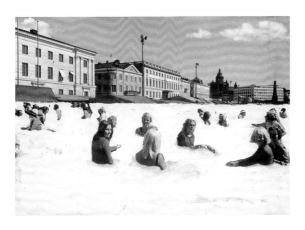

Do You Come Here Often? 1993
Cibachchrome of manipulated postcard on foamboard on MDF
42 x 59 cm
Collection of Lotta Hammer
Photograph Zouzsa Berini

one of those artists who make the weather – literally, by her concoctions of water, salts and dyes – but also in the predictive sense. The way she shows is not reassuring. She is not alone in working with weather, or simulating natural effects. Is this because we all sense a great change coming? Do we want memorials or reminders before disaster strikes? Watching the reactions to Olafur Eliasson's misty sun at Tate Modern – the Turbine Hall itself containing it like a vast case – it was impossible to believe that these were just about the British obsession with talking about the weather that the artist himself claimed. There was a sense of elegy as well as wonder. But it would be wrong to end on a doomy note. Neudecker says people have sometimes missed her humour; she would not want to seem too serious – too German. In one of her altered photographs (1993), she hints at a new ice age. Helsinki, again, appears in what looks like a standard tourist's postcard. But this time, a group of people are buried almost to their necks in snow. They seem happy enough, chatting and playing, and it has not yet covered the various layers of the city's

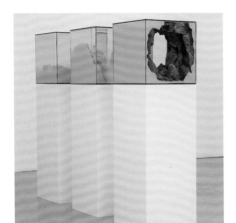

Over and Over, Again and Again
2004 detail

Over and Over, Again and Again 2004
Glass, water, acrylic medium, salt, fibre glass, plastic
47.6 x 47.6 x 48.2 cm each tank (triptych) Edition 3 + 1AP
Commissioned by the Met Office for Elemental Insight
Photograph Woodley and Quick

history – the Russian Orthodox church, the grand, proconsular building of the Swedish embassy. *Do You Come Here Often?* (1993) is the caption – jokily banal; almost as banal as talking about the weather. One answer might be, yes, but there wasn't so much snow last time. The work seems light, an entertainment, playful as well as profound. Yet prophetic too, since this is the same city to which Neudecker herself returned, to follow Schubert, Müller and their wanderer on his own unending journey. This is Neudecker – geographer, cartographer, choreographer of our tracks in the snow.

With thanks to Mariele Neudecker, Susan Daniel-McElroy and Sara Hughes.
1 Maite Lorés, 'The Magic Mountain: The Work of Mariele Neudecker', in *Mariele Neudecker*, exhibition catalogue, firstsite, Colchester, 1999, p15.
2 Immanuel Kant, *Critique of Judgement*, Oxford 1952, p98.
3 Ruthven Todd, *Tracks in the Snow. Studies in English Science and Art*, London 1946, p2.

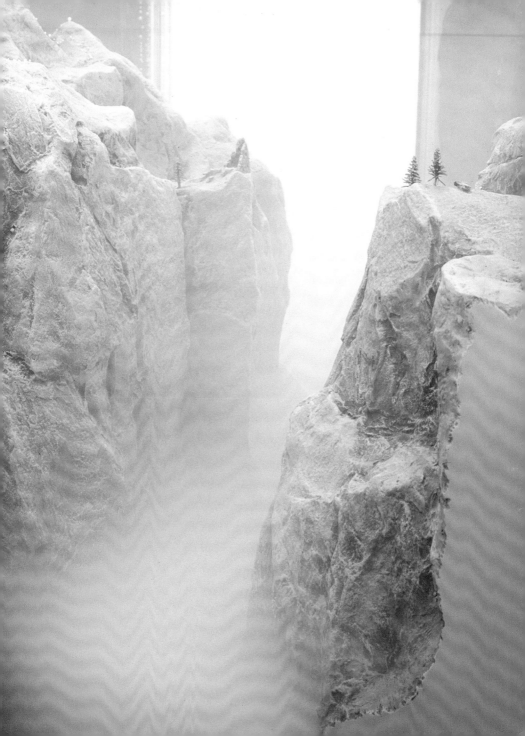

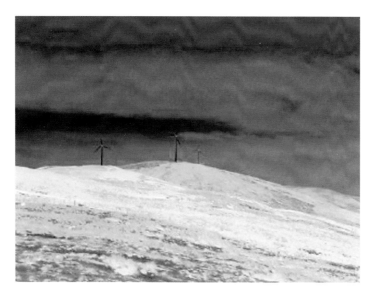

Winterreise 2003
Die Nebensonnen (The Phantom Suns)
Film still
Commissioned by the Contemporary Art Society
Special Collection Scheme on behalf of Leeds City Art Gallery
with Funds from the Arts Council Lottery, 2003
(in collaboration with Opera North)

The Three Phantoms of Winterreise
'Drei Sonnen sah ich Himmel steh'n'

Douglas Young

1. Winterreise as Exile

Culture is the rule – art is the exception.[1] Few Works are as exceptional as Schubert's vast 'song-cycle' of 1827 – *Winterreise* (Winter Journey). Often regarded simply as 24 songs of unrequited love, to which the bourgeoisie listen '*with their eyes closed*', the thematic origins of *Winterreise* are complex and disturbing.[2]

Schubert (b 1797) was the son of economic migrants. His artisan parents had fled south from Silesia and Moravia in the 1780's to seek prosperity in the newly liberal Vienna of Emperor Joseph II. But Schubert's early life was overshadowed by war; by Napoleon's occupation of Vienna (1805); by economic collapse (inflation, currency devaluation); and by the imposition of a police state under Metternich's control – a control that became ever more repressive when a student assassinated the popular entertainer and police informer Kotzebue (1819).

By then, Schubert was part of a young, radical circle that included writers, revolutionaries, atheists, homosexuals, and the new breed of industrial entrepreneurs, who met weekly to discuss art and current affairs. On a stormy night in March 1820 one such gathering was raided by the security police. Schubert was lucky to be released after questioning. But Johann Senn (who may have been implicated in a plot to assassinate Metternich) was imprisoned without trial for 14 months and then exiled to the Alps. Schubert (who by now had contracted the syphilis which was to hasten his death in 1828) never saw him again.

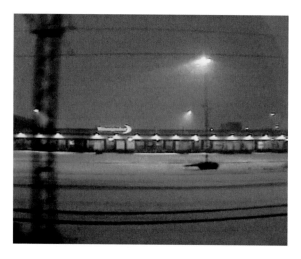

Winterreise 2003
Film still

Does any of this have a contemporary ring? We think of Schubert as the soul of *gemütlich* Vienna; but it is unlikely that he felt warmly disposed towards the Imperial GHQ. He lived with the perpetual fear of deportation: *'A stranger I came / A stranger I depart'.*[3] Perhaps *Winterreise* was the projection of that fear? It certainly renders Mariele Neudecker's decision to film her own *Winter Journey* at latitude 60 north, chillingly appropriate.

2. Winterreise as Soundscape

Maurice Ravel coined the *phrase 'Sites Auriculaires'* to describe musical compositions in which he evoked a particular place through musical translation of its characteristic sounds. Although composed 70 years earlier, *Winterreise* abounds in such sound-painting: clattering weathervanes; the rustle of leaves, howling storms; biting sleet; a distant posthorn; dogs barking at night in the silent village; the trite tune of a hurdy-gurdy. Prior to Schubert, songs had been simple affairs – a classical *pas-de-deux*: the

reverential accompanist supporting the arabesques of a vocal *prima ballerina*. But in *Winterreise* the singer is buffeted by the *Sturm und Drang* of Beethovenian piano writing. At times he seems merely to comment on the drama painted, in rapid, violent, contrasts, by the keyboard.

It was this paradox that enabled Liszt (a generation later) to transcribe and rework *Winterreise* for solo piano. Both Schubert's and Liszt's musical textures have a visceral, tactile quality, like the furrowed surface of a Constable oil – sound applied with a palette-knife! The primeval musical landscapes of Mahler, Bartok and Messiaen are already close.[4]

But *Winterresise* is also an 'inner-landscape' – an early example of interior monologue. Apart from the protagonist there are no other characters on this winter journey. As he trudges, exhausted, through the snow, he imagines three 'phantom suns' in the darkening sky: a surreal hallucination straight from Büchner's (and Berg's) psychotic *Woyzeck* (1836) – or from the expressionist fantasies of Schoenberg's *Erwartung* (1910).[5]

3. Winterreise as Dogme

What Thomas Mann called Romanticism's *'deep pessimism, its musical attachment to night and death'* counterbalanced, indeed outweighed, the 19th century's liberal faith in science, reason and progress. This complicity with the dark (so strong in Wagner and Baudelaire) can already be felt in *Winterreise*, and has held a powerful fascination for cinema, from *Nosferatu* to *Blade Runner*. It has been most intelligently analysed in the work of Ingmar Bergman. Journeys that are also metaphysical Quests underlie several of his greatest films: *Wild Strawberries* (1957), *The Silence* (1963), *Persona* (1966) and *Shame* (1968), while tortured interrogation of ultimate questions informs *Winter Light* (1961) and *Cries and Whispers* (1972).

But whereas Bergman has usually sought thematic resolution in his films, Antonioni is closer to the ambiguity and paradox of *Winterreise*. The long,

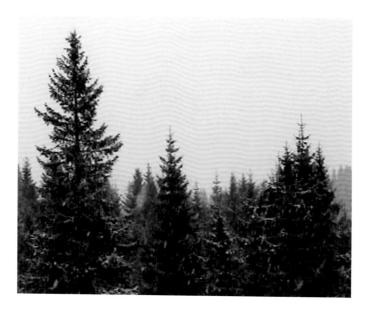

Winterreise 2003
Rast (Rest)
Film still

futile search for a vanished woman, in *L'Avventura* (1960) leaves the *'road of meaning open and as if undecided'.*[6] In the cold Taormina dawn, where the film stops arbitrarily, we are left only with unanswered questions.

Neudecker's new film of *Winterreise* shares many themes and images with Antonioni (the looming ships and uneasy wastelands of *Il Deserto Rosso;* the disorientating waters and fogs of the Po; the sense of everything becoming more and more distant). But her method of work is nearer to the DOGME film-makers, Winterberg and von Trier. By adopting a set of rules, or codes (similar to the DOGME Manifesto of 1995) Neudecker's camera is able to investigate its subject from unorthodox angles, disturbing established meanings.[7]

Art is an artificial construct which comes, in time, to seem 'natural'. Today, Schubert's *Winterreise* is absorbed within the bourgeois category of 'tragic masterpiece'. But this radical *opera aperta,* which ends with a barrel-organ churning out a corny pop tune, completely rejects the certainties (and consolations) of tragedy.[8] Is it a 'song-cycle' at all? There is nothing 'cyclical' here: our anti-hero has a one-way ticket. And can these ice-bound images be adequately described as 'songs'? Over this winter landscape snow still falls, with sly, deceptive softness – obliterating all contours; erasing all footprints; until the land, sea and sky dissolve in a smothering, blinding, whiteness.

1 From Jean-Luc Godard's film *JLG/JLG Autoportrait de Décembre* (1995). *'The rule is culture. Culture is a question of rules – it's a part of the rules. Exception is a question of art – it's part of art.'*

2 Roland Barthes – *'In the 18th century the aristocracy listened to music with their eyes open whereas today the bourgeoisie close their eyes when they listen to the piano.'* (Lecture given in Alexandria 1949). In *Mythologies* (1952 – 4) Barthes revealed the ideological misrepresentation (the social 'lie') inherent in cultural forms. *'I resented seeing Nature and History confused at every turn.'*

3 The opening line of *Winterreise*. Wilhelm Müller's first collection of 12 poems had been published in the 1823 almanac *Urania*. The second group of 12 poems was published in November 1824. Müller was a member of a group of writers and political radicals in Berlin.

4 In *Der Abschied* (Farewell) from Mahler's *Das Lied von der Erde* (1908) the singer often falls silent for minutes at and end, while the orchestra continues the musical discourse. In some ways Olivier Messiaen's *Catalogue d'Oiseaux* (1955–8) – a vast musical landscape of great originality – can be seen as a descendant of *Winterreise* and of the 19th century 'song without words'.

5 Alban Berg used Büchner's fragmentary play as the basis of his opera *Wozzeck* (1914–22, premiered 1925). Berg was a member of Kandinsky's *Blau Reiter* circle, as were Arnold Schoenberg and Anton Webern. Schoenberg's monodrama *Erwartung* is often seen as a musical parallel to Kandinsky's first 'abstract' paintings.

6 From Roland Barthes' lecture *Caro Antonioni* given in Bologna February 1980. *'The artist has no power, but he has some relationship with truth.....his world is truth seized indirectly.'* / *'....its identity suddenly slips into a new space, that of the interstice'.* See also John Berger's essay: *Opening a gate from* his book *The Shape of a Pocket* (2001).

7 The full text of the DOGME 95 Manifesto can be found in *'The Name of this Book is Dogme 95'* by Richard Kelly (Faber 2000).

8 *Opera Aperta* – a collection of essays by Umberto Eco (1962 – 68) published in English as *'The Open Work'* (Hutchinson Radius 1989). Unusually for the early 19th century, *Winterreise* contains many of the characteristics of a modern 'open work'.

Mariele Neudecker

1965 born in Düsseldorf, Germany

lives and works in Bristol, UK

EDUCATION

1991–92 Chelsea College of Art and Design,
London, (MA Sculpture) .

1987–90 Goldsmiths College, London
(BA Hons Degree)

1985–87 Crawford College of Art and Design,
Cork, Ireland

SELECTED SOLO EXHIBITIONS

2004

"Over and Over, Again and Again",
Tate St Ives, Cornwall, UK

"Much Was Decided Before You Were Born",
Galerie Barbara Thumm, Berlin, Germany

"Between Us", Tullie House, Carlisle, UK,
Laing Gallery, Newcastle

"Winterreise", Opera North Project (various
venues)

2003

"Between Us", Bluecoat Gallery, Liverpool, UK,
Leeds City Art Gallery, Leeds, UK,
The Glynn Vivian Art Gallery, Swansea, UK

"Winterreise", Opera North Project (various
venues)

2002

"Between Us", Chapter Art Centre and
HG-Gallery, Cardiff, Wales, UK

2001

"Until Now", Galerie Barbara Thumm, Berlin,
Künstlerhaus Bethanien, Berlin, 1stSite at the
Minorities, Colchester, UK

2000

"Until Now", Ikon Gallery, Birmingham, UK

1999

"Never Eat Shredded Wheat" (Memory Maps),
James Harris Gallery, Seattle

"Never Eat Shredded Wheat", curated by Leslie
Brothers, I-Space, The Krannert Art Museum,
Chicago

1998

"New Work", Galerie Barbara Thumm, Berlin

"The Air We Breath is Invisible",
Middelesbrough Art Gallery, Middelesbrough

"Shipwreck", project space, Gio Marconi,
Milano

"Unrecallable Now", Spike Island, Bristol

"The Halted Traveller", Bergens Kunstforening,
Bergen, Norway

SELECTED GROUP EXHIBITIONS

2004

"Into My World: Recent British Scupture", The
Aldrich Contemporary Art Museum, Ridgefield,
USA

"Zwischenwelten", Haus Esther-Haus Lange,
Krefeld

"Elemental Insight", MET Office, Exeter

"Natural Histories: Realism Revisited",
Scottsdale Museum of Contemporary Art
(SMoCA), Scottsdale, Arizona, USA

"Other Times", City Gallery Prague, Prague
(Czech Republic)

2003

"Berlin-Moskau,Moskau-Berlin: 1950–2000",
Walter-Gropius-Bau, Berlin

"Orifice", Museum of Modern Art, Melbourne, Australia

"From Dust to Dusk", Museum of Contemporary Art, Copenhagen, Denmark

"Brightness works from the Thyssen-Bornemisza Contemporary Art Foundation", Museum of Modern Art Dubrovnik, Dubrovnik, Croatia

"Strange and Beautiful", Sketch, London

"Danger Zone", Kunsthalle Bern, Switzerland

"Out of Place", Harewood House, Yorkshire, UK

"Liquid Sea, Museum of Contemporary Art, Sydney, Australia

"micro/macro – British Art 1996–2002", Muczarnok, British Council Exhibition, Budapest,Hungary

"The Idea of North", Green on Red Gallery, Dublin, Ireland

2002

"Frozen", Site Gallery, Sheffield, UK

"Judie Bamber, David Deutsch, Moira Dryer, Mariele Neudecker", Gorney Bravin + Lee Gallery, New York

"Humid", The Auckland City Art Gallery, Auckland, New Zealand

"IMAGINATION-Romanticism", The Brno House of Arts, Czech Republicm and Galway Art Centre, Ireland

"At Sea", Sainsbury Centre for Visual Arts, University of East Anglia, Norwich, UK

"Here, There, Elsewhere", London Print Studio Gallery, London, UK

"Conquistadores of the Useless", contemporary art at the Alpine Club,London

"Der Berg", Heidelberger Kunstverein, Heidelberg, Germany

2001

"Utopien heute? Kunst zwischen Vision und Alltag", Wilhelm-Hack-Museum Ludwigshafen/Germany

"IMAGINATION-Romanticism", Jena, Germany

Skulptur-Biennale Münsterland, Kreis Steinfurt, Germany

Yokohama International Triennale of Contemporary Art, Yokohama, Japan

"Bright Paradise", Auckland Art Gallery, New Zealand

Sonsbeek 9 "Locus Focus", Arnheim, The Netherlands

"Artline V", Borken/ Germany

"Superman in Bed", Collection Gaby and Wilhelm Schürmann, Museum am Ostwall, Dortmund/Germany

"At Sea", Tate Liverpool, UK

"Humid", Spike Island, Bristol, UK and Melbourne Festival, Australia

"Time Odyssee", Galeria Luis Serpa Project, Museo National de Historia Natural, Sala de Veado, Lisbon, Portugal

"Total Object Complete with Missing Parts", Tramway, Glasgow, UK

"Landskap", Uppsala Konstmuseum, Uppsala, Sweden

2000

Waterfront, Helsingor, Denmark

"Blue", Launch Exhibtion, The New Art Gallery Walsall, Walsall, UK

"The Wreck of Hope", The Friedrich Society, The Nunnery Gallery, London, UK

"Utopias", Mead Gallery, Warwick, UK

Published by Tate St Ives to accompany
the exhibition

Mariele Neudecker
Over and Over, Again and Again

21 May – 26 September 2004

Mariele Neudecker would like to thank all the
individuals and organisations for their help
and support in the making of this exhibition
and accompanying publication

ISBN 1 85437 530 X

A catalogue record for this publication is
available from the British Library

Editors Susan Daniel-McElroy,
Sara Hughes and Kerry Rice

Design Groundwork, Skipton

Print + repro Triangle, Leeds